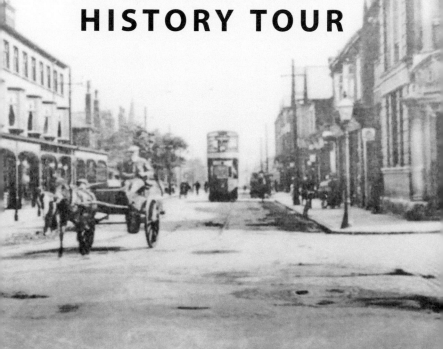

WALLASEY

HISTORY TOUR

First published 2020

Amberley Publishing
The Hill, Stroud,
Gloucestershire, GL5 4EP
www.amberley-books.com

Copyright © Ian Collard, 2020
Map contains Ordnance Survey data
© Crown copyright and database
right [2020]

ISBN 978 1 3981 0068 8 (print)
ISBN 978 1 3981 0069 5 (ebook)

British Library Cataloguing in
Publication Data.
A catalogue record for this book is
available from the British Library.

Origination by Amberley Publishing.
Printed in Great Britain.

INTRODUCTION

The name Wallasey comes from the Germanic word 'Walha', which is translated as 'stranger or foreigner' and is also the origin of the name Wales. Wallasey is bounded by the Irish Sea to the north, by the mouth of the River Mersey to the east and by the inlet of a river to the south-west. The Domesday Book of 1086 states that the Saxon landowner Ulstred had been dispossessed of his lands, which were awarded by William I to the Earl of Chester and then held by Robert de Rhuddlan.

The development of Wallasey was greatly influenced by the fact that the area consists of new red sandstone from sea level to nearly 200 feet. The sandstone rock extends from the Red Noses in the north down to another ridge at Seacombe. The Anglo-Saxons controlled the Wirral around AD 613 and they occupied areas such as West Kirby, Frankby and Irby. In the sixteenth and seventeenth centuries, horse races took place on Leasowe sands and these were organised by the Earls of Derby and regarded as the forerunners of the Derby races.

In the reign of Edward II, the manor of Wallasey became part of the fee of Halton as Robert de Rhuddlan died without heirs. Liscard was held by the Astons and lands at Pulton paid rents in 1816 to Halton. The lordships and manor of Liscard was advertised for sale by public auction on 20 August 1800 and sold to John Penkett for £2,513. James Atherton, a local merchant, purchased around 170 acres of land at Rock Point in 1830. He planned to develop a 'favourite and fashionable Watering Place' with residential homes, a church, hotel and ferry and establish packets between that place and Liverpool.

With the increase in housing developments at the beginning of the twentieth century Egremont, Liscard, New Brighton, Poulton, Seacombe and Wallasey Village gradually merged together to become the town of Wallasey, and county borough status was granted in 1913. The district of Moreton was added to the borough in 1928, and in 1974, following local government reorganisation, Wallasey became part of the metropolitan district of Wirral.

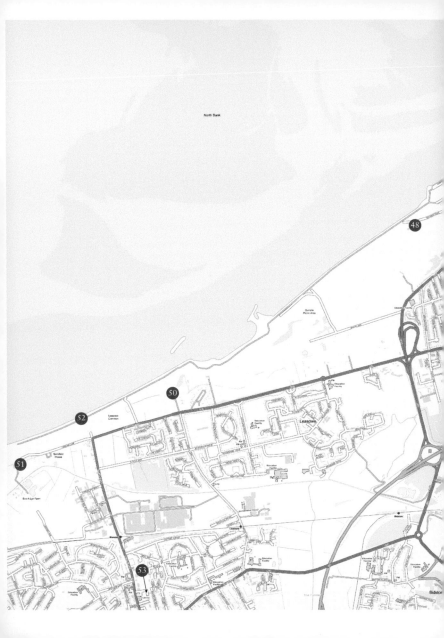

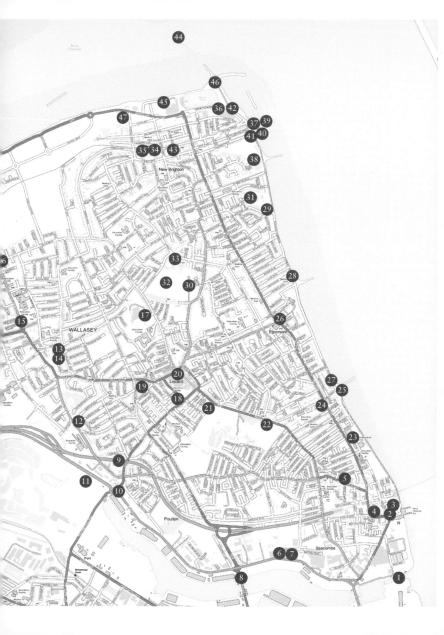

KEY

1. ALFRED DOCKS

The Great Western Railway and the London & North Western Railway wanted access to the docks on the Mersey and were interested in the plans for facilities on the Wirral side of the river. Sir John Tobin and John Askew had purchased land on the river and Thomas Telford was asked to assess the possibility of building a port. After much experimentation new entrances were built at Alfred Dock and they were opened by HRH the Duke of Edinburgh on 21 June 1866.

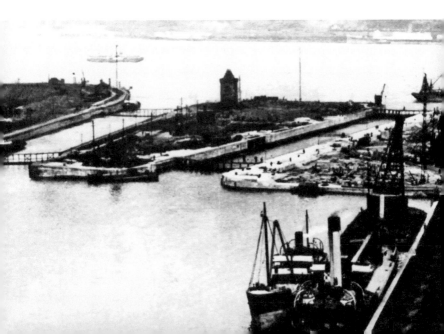

2. SEACOMBE FERRY TERMINAL

Sailing boats were used to take people across the River Mersey to Liverpool up to 1823 when they were replaced by steam-driven vessels. By 1840 a floating landing stage was installed at Seacombe, and the ferry was connected to the Seacombe Hotel. A new pier at Seacombe had been opened in 1880 and a floating roadway was added in 1925, so that vehicles could be transported across the river. In 1933 there were sixteen bus routes in Wallasey and buses waited at Seacombe for passengers to embark from the ferry.

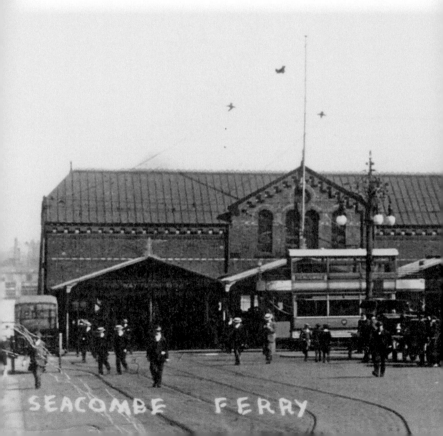

SEACOMBE FERRY

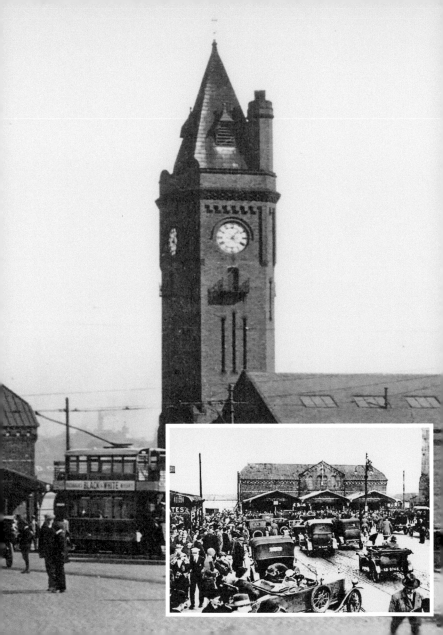

3. SEACOMBE FERRY HOTEL

The Seacombe Ferry Hotel was built with twenty-five bedrooms, all with hot and cold water and electric fires. The hotel was provided with a lift to all floors and was mentioned in the Good Food Guide. It was demolished in 1978 and was replaced by a smaller hotel, which has now been demolished.

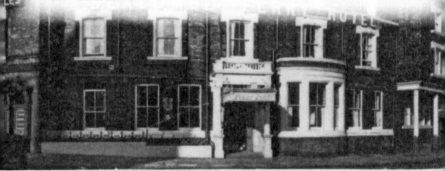

★
SEACOMBE FERRY HOTEL

A.A. **WALLASEY** R.A.C.

Fully Licensed

On River Front, Opposite to Ferry
Liverpool within 10 minutes

25 BEDROOMS, ALL WITH H. & C.
Lift to all Floors
Central Heating and Electric Fires throughout
Cocktail Bar open for Residents and Dining Room Patrons
RENOWNED FOR ITS CUISINE

TARIFF ON APPLICATION Tel. : Wallasey **142**

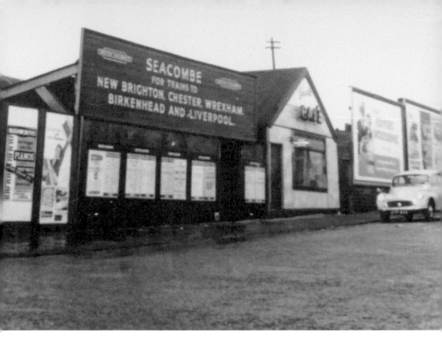

4. SEACOMBE RAILWAY STATION

The rail branch from Bidston to Seacombe was opened on 1 January 1895 with an intermediate station at Liscard and Poulton. The following year trains of the Dee & Birkenhead Committee commenced running over the branch. On 4 January 1960 the Seacombe branch was closed to passengers and to goods three years later.

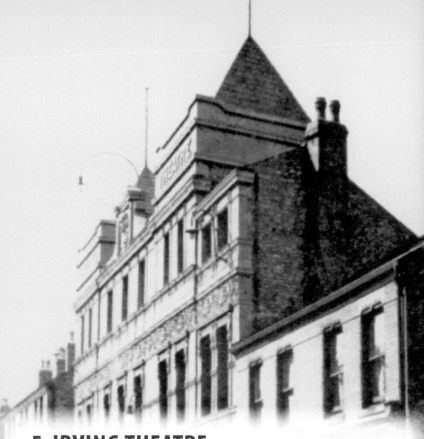

5. IRVING THEATRE

The Irving Theatre in Borough Road, Seacombe, was opened on 18 December 1899. Sir Henry Irving allowed his name to be used on the understanding that only quality drama was produced at the theatre. In 1924 it was known as the Irving Repertory Theatre but became The Hippodrome in 1928. The theatre was closed on several occasions over the next few years and when the Buxton Theatre Circuit took it over in 1936 it became the Embassy and was operated as a cinema. In 1959 it became a bingo hall.

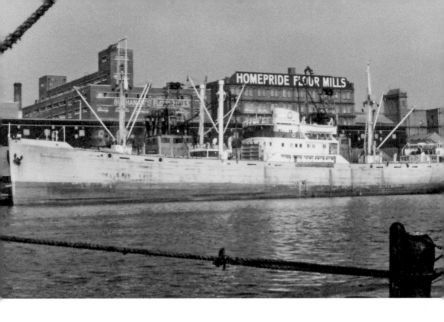

6. EAST FLOAT DOCK

In 1865 large grain warehouses were built at the East Float Dock at Wallasey to deal with the increasing number of imports of grain from European and Black Sea ports and later North and South America, India and Baltic cargos. The grain was initially shipped from the docks by rail but by the end of the nineteenth century the milling companies converted many of the corn warehouses into factories, which also bagged the flour that was then sent by rail, and later by road, to inland destinations.

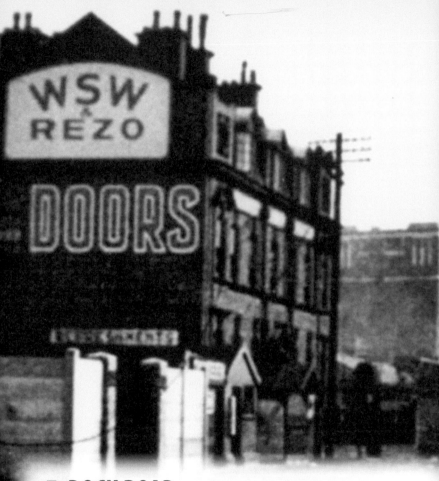

7. DOCK ROAD

Dock Road in Wallasey consisted of grain warehouses, offices and the works of the ship propeller manufacturer Stone Marine Propulsion. The company have been designing and manufacturing propellers for over 200 years for many famous ships built in Britain and across the world.

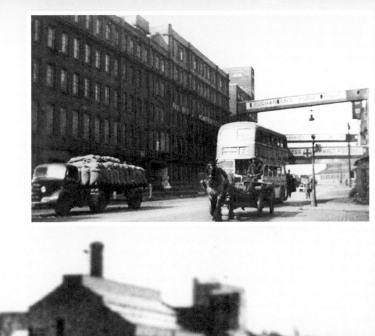

8. DUKE STREET

A steam engine crosses Duke Street Bridge, which is one of the main roads connecting Wallasey with Birkenhead. At the entrance to the berths at Duke Street there was a permanent police box where an officer directed the traffic day and night and vehicles were held up when a goods train steamed past. The railways held an important role in the transport system of the docks up to the 1970s, and there were lines to most quays and a large goods depot at Morpeth Dock in Birkenhead.

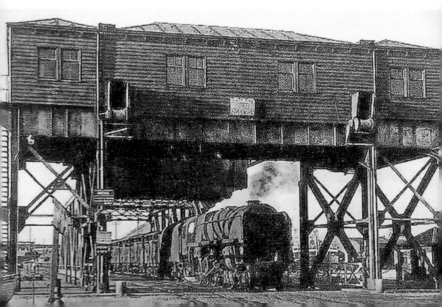

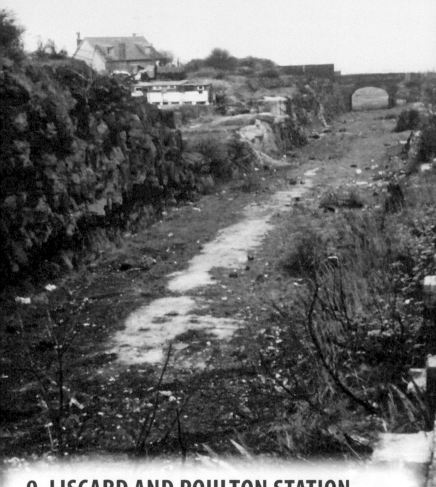

9. LISCARD AND POULTON STATION

Liscard and Poulton station opened in 1895 on the Bidston to Seacombe branch line. When it was closed to passengers and freight in 1963 the line was converted into a road to take the vehicle traffic from the Kingsway Mersey Tunnel, which opened in 1971.

10. BIRD'S HOUSE

Bird's House in Limekiln Lane, at the junction with Poulton Bridge Road, is one of the oldest houses still standing in Wallasey. It was built for William Bird in 1697. Several years ago the roof was renovated and it was discovered that the timbers were made up of old ship's masts. The name of Limekiln Lane derived from the fact that there was a limekiln in the vicinity. The world-famous opera singer Rita Hunter was born at No. 27 and attended Liscard Secondary School. Rita sang at most of the major opera houses of the world and was awarded a CBE in 1980.

11. BIDSTON DOCK

Bidston Dock was opened in March 1933 as an extension to the West Float. In the 1950s facilities were provided at the dock for unloading iron ore and its transportation to Shotton in North Wales. Three large moveable cranes were installed and a rail line was connected to the Wrexham main line at Bidston station. When the iron ore trade ceased the cranes were demolished, and the dock was closed and landfilled by 2003.

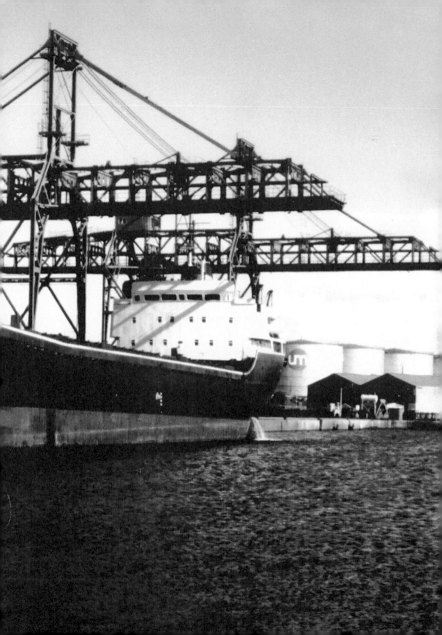

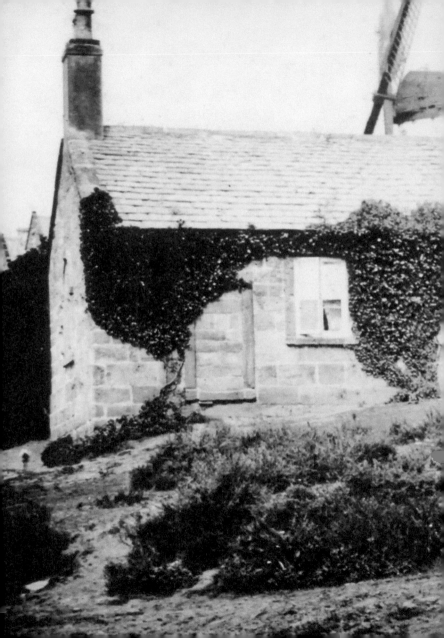

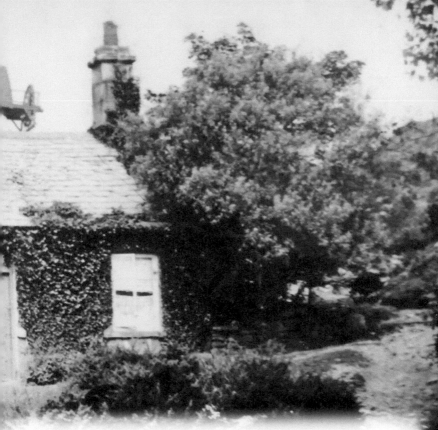

12. THE OLD SCHOOL HOUSE

The Old School House. The plaque inscription states: 'This Cottage was erected by public subscription in 1799 to serve as the Wallasey Grammar School replacing that which had existed from 1656 under the same roof as the old Parish Church of St Hilary. It was so used until January 1864 when the school was transferred to new premises erected by the Trustees in St Georges Road. In 1873 a further move was made to Withens Lane upon which site the present school has developed.'

13. ST HILARY'S CHURCH

St Hilary's Church was founded by St Germanus between AD 445 and 447. The church has been rebuilt several times and has suffered two serious fires. In 1549 the church had three bells and as one had cracked it had to be recast in 1624. By 1672 it had cracked again and was recast by Scott of Wigan. A new ring of five bells was installed in 1724 and two of these were named after two of the churchwardens at the time.

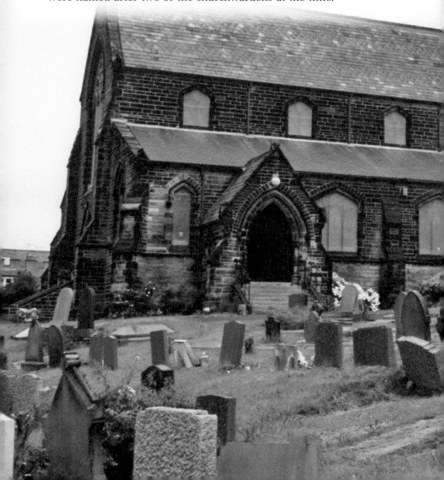

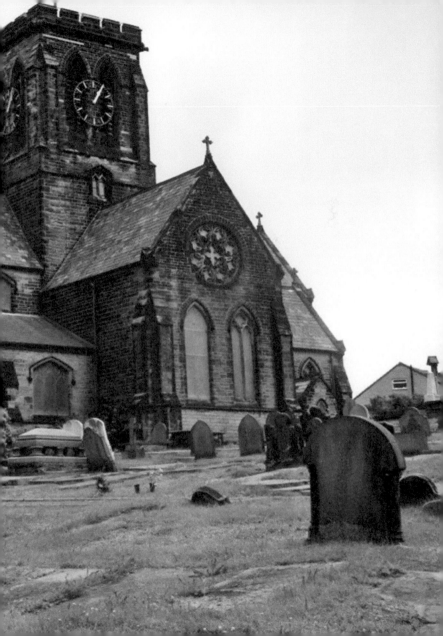

14. ST HILARY'S CHURCH TOWER

St Hilary's Church tower is one of Wallasey's oldest building and dates back to 1530. On the Sunday morning of 1 February 1857 a fire destroyed the church building. It was reported that the congregation had complained about the cold in the building and the sexton had stoked the boilers with too much wood and coal.

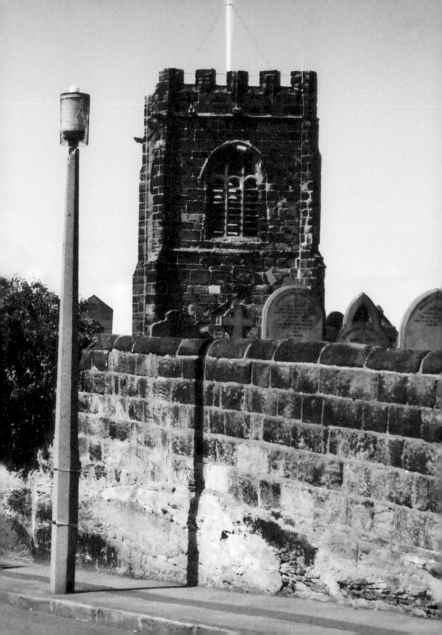

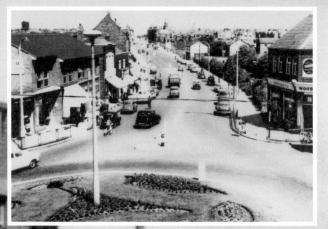

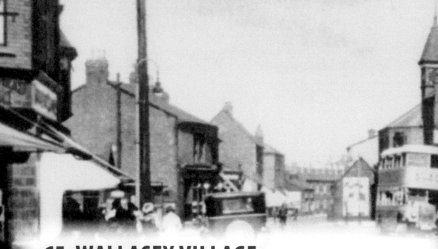

15. WALLASEY VILLAGE

Wallasey Village is bordered by the suburbs of New Brighton to the north-east, Liscard to the east and Poulton to the south-east. The village was known as 'Kirkby in Walley' up until the fifteenth century, from the Norse meaning 'village with a church' and Walea, the Anglo-Saxon name for Wallasey in the Domesday Book. It is mainly a small residential area with shops, public houses and other retail facilities.

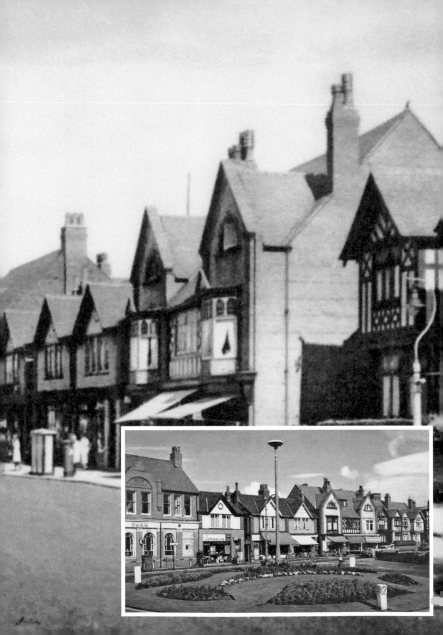

16. THE GROVE ROAD HOTEL

The Grove Road Hotel was built in 1908 and continued as a hotel until the 1920s when it became the Grove Café, owned by S. Reece & Sons, who operated a confectioner's shop on the site. The Melody Inn Club was established on the first floor of the building until it was destroyed by a fire in the 1960s.

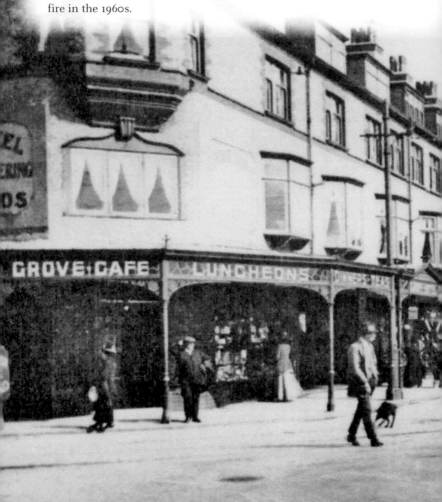

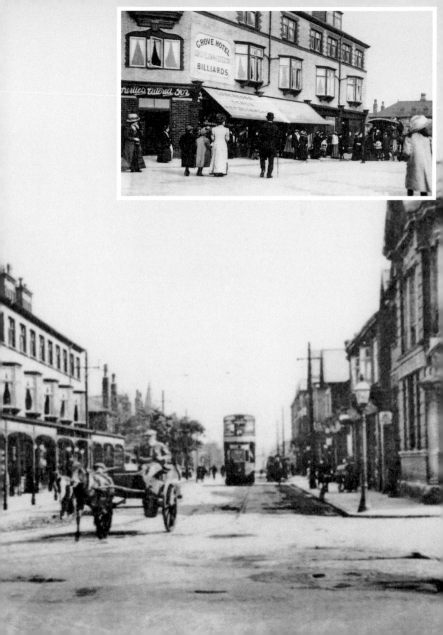

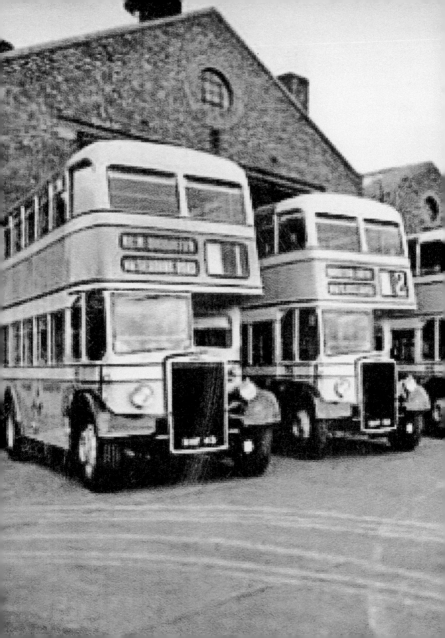

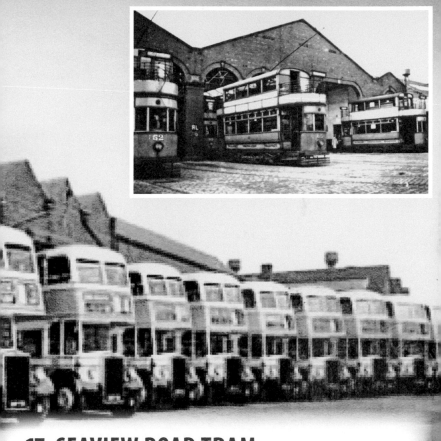

17. SEAVIEW ROAD TRAM
AND BUS DEPOT

Seaview Road Tram and Bus Depot in 1933. The Wallasey Tramways and Improvements Act of 1899 gave the Corporation the power to obtain the Wallasey United Tramway and Omnibus Company. A line was opened from Seacombe Ferry to New Brighton Ferry in March 1902, followed by another via Seabank Road, and a third via Warren Drive. The Seabank Road service survived until 1929 and the whole system was closed in 1933.

18. ST ALBAN'S CHURCH, LISCARD

In 1841 the parish of St Anthony's in Liverpool was looking for a place for worshippers to hold services and hold Mass in Wallasey. A joiners shop in Union Street was first used and Mrs Mary Hall later offered her public house, the Hen & Chickens, to be used for this purpose. A schoolhouse was opened in 1842 and this was used for holding services. The foundation stone of St Alban's Church was laid on 8 June 1852, and the church was opened by the Archbishop of Westminster, Cardinal Wiseman, on 18 September 1853.

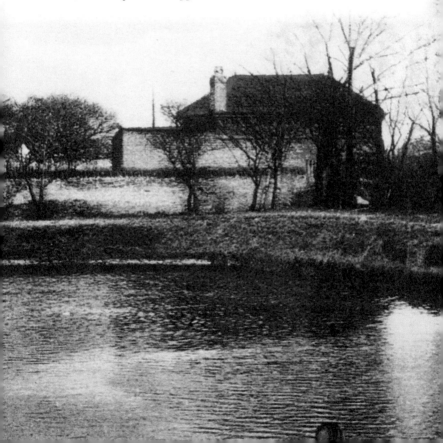

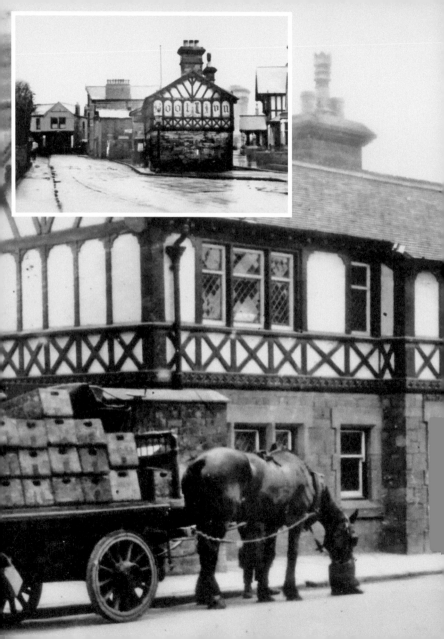

19. THE BOOT INN

There has been a public house on this site since Elizabethan times and the present building was erected in 1926 when the road was widened. The origin of the name dates back to the reign of Queen Elizabeth I. A traveller arrived with a large boot in his hand and as the landlord was serving him he heard the sound of coins and deduced that they had been stolen. The landlord overcame him as three men arrived to confirm that the gold coins had been stolen. The thief was hanged and the landlord rewarded, and the boot was left as a sign for the inn. Another theory is that the name derives from the boot shop next door to the inn.

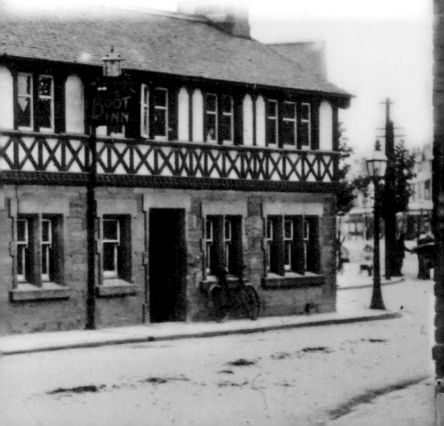

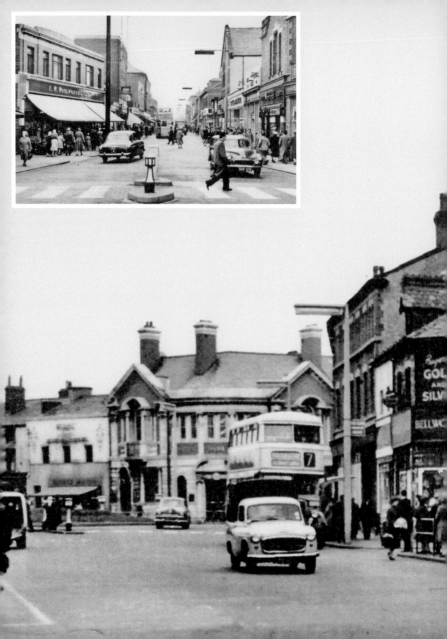

20. LISCARD

Liscard developed as one of the main shopping areas in Wallasey, but declined in importance with the development of the ferry and railway services at the beginning of the twentieth century. However, the shopping centre grew after the First World War and the comprehensive network of tram services helped in its development.

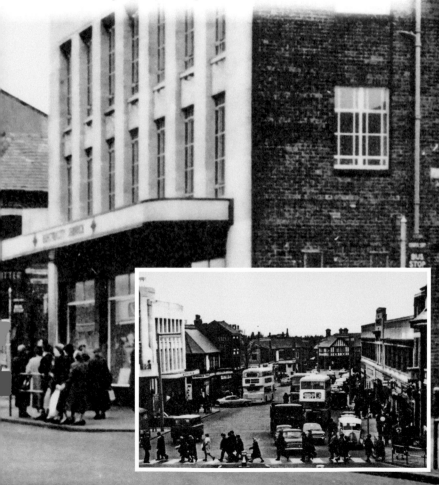

21. VICTORIA CENTRAL HOSPITAL, LISCARD ROAD

The foundation stone for Victoria Central Hospital was laid in 1899 and the forty-four-bed hospital opened in 1901. A bazaar held in 1890 in aid of the hospital raised £6,000 and when the hospital was opened it was supported by subscriptions and contributions. It became part of the National Health Service in 1948 and in 1957 a new £95,000 extension was built, incorporating an outpatient department, a minor operating theatre, four laboratories and a physiotherapy department. The services at the hospital were closed in 1982 and transferred to the new Arrowe Park Hospital.

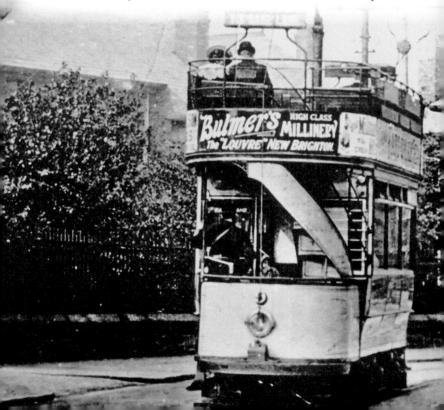

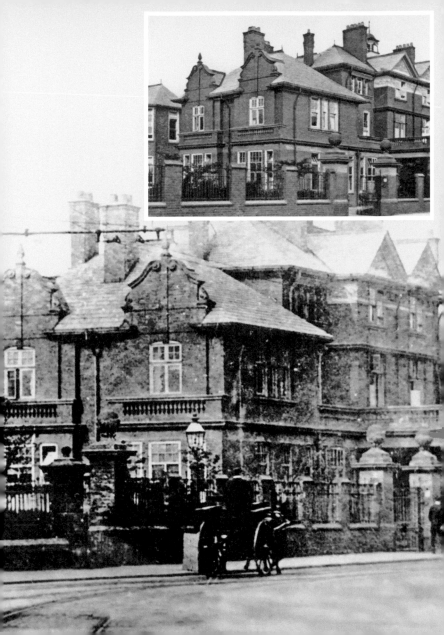

22. ST JOHN'S CHURCH

St John's Church in Liscard Road is built on land that once belonged to Birkenhead Priory and was purchased by Sir John Tobin from F. R. Price around 1830. The church opened on 19 May 1833 and could accommodate up to 1,500 people. It was renovated and redecorated in 1933 at a cost of £700. In the Second World War the building suffered damage and this was not completely repaired until 1954.

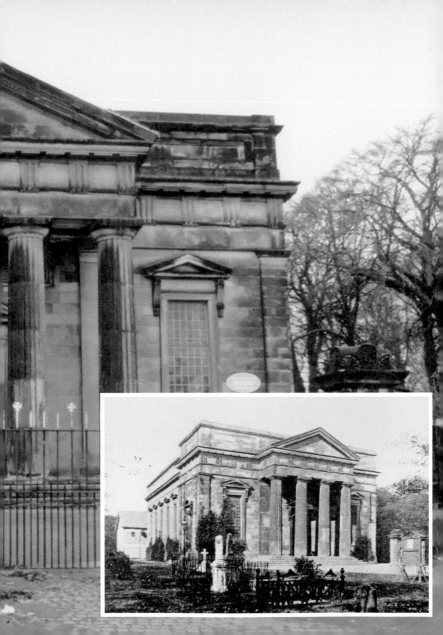

23. WALLASEY TOWN HALL

Wallasey Town Hall was built by Moss & Sons of Loughborough, who started work in 1913. The foundation stone was laid by King George V on 25 March 1914. It was used as a hospital during the First World War, with beds for 350 sick and wounded soldiers. The Town Hall was officially opened by the Mayor of Wallasey on 3 November 1920, and is 36 feet above the promenade.

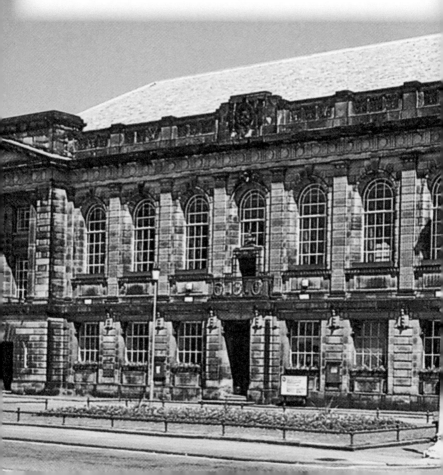

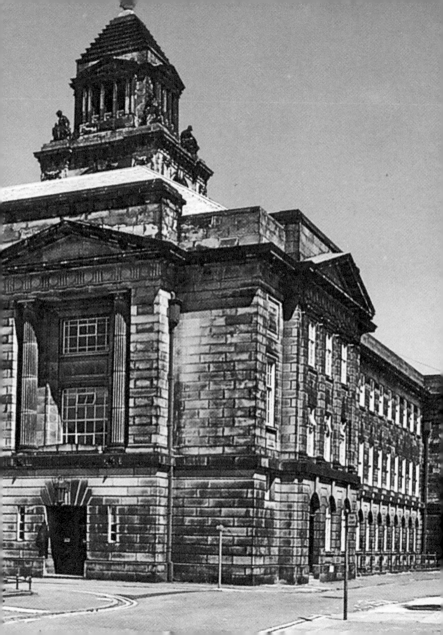

24. KING STREET

King Street in the 1920s. It was named after Ellen King, who owned most of the land, and was previously known as Barn Lane. There was a large furniture shop, booksellers, stationers and sweet shop. Two local photographers, Keith Medley and Bob Bird, operated from a shop in Brighton Street, which included a studio, office and two darkrooms. Both men later moved into taking photographs for the local newspapers and had built up a vast collection of images of Wallasey and its people over the years.

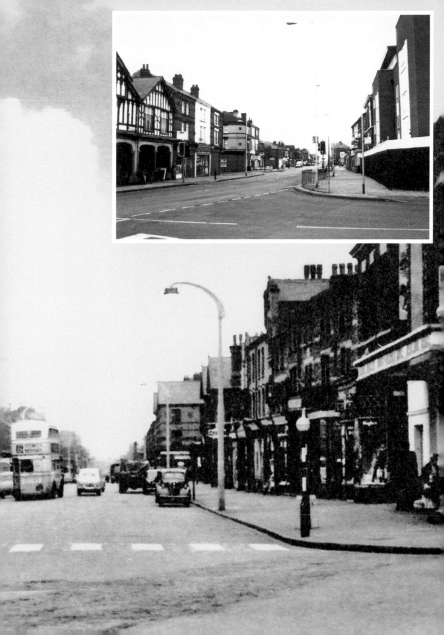

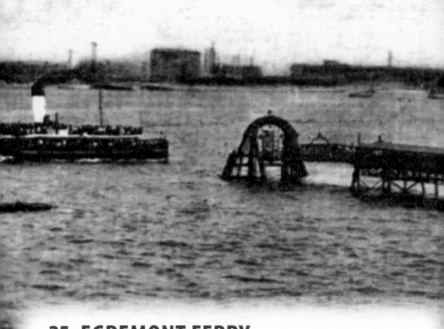

25. EGREMONT FERRY

The ferry from Egremont to Liverpool was established in the first half of the nineteenth century. The name of the Egremont ferry came from the house of Captain John Askew, a Liverpool harbour master, which stood at the bottom of Tobin Street. He purchased the ferry rights in 1830 and landing at Egremont was made by a wooden jetty until a pier was installed in 1835. The pier was damaged on the night of 12/13 May 1941 by the coaster *Newlands*. It was decided that the damage was so extensive that the ferry service from Egremont would end. The stage was broken up at Tranmere and the other sections of the pier were dismantled, the work being completed in August 1946.

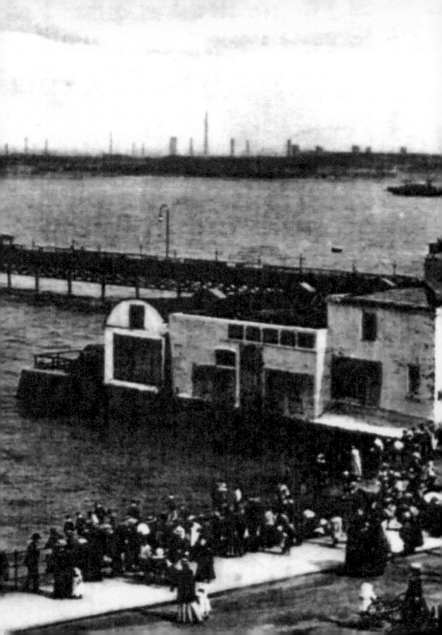

26. THE MARINERS HOMES

The Mariners Homes were built in 1882 from a donation by William Cliff, who was a local shipowner and merchant. They were built in memory of his daughter, Rosa Webster, who died in 1879, aged twenty-four. The grounds were the gift of the trustees of the late Roger Lyon Jones. The tower was 135 feet high and contained a clock and a bell. They were opened on 16 December 1882 by HRH the Duke of Edinburgh, second son of Queen Victoria. Cottages were also built for mariners and their families.

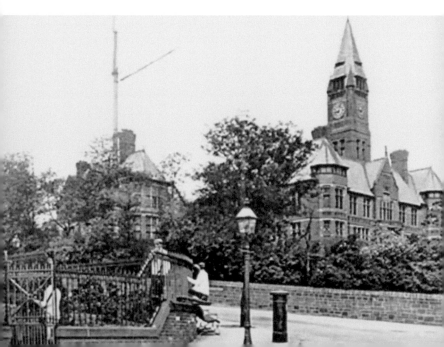

27. EGREMONT PROMENADE

Egremont Promenade with Vale Park and New Brighton Tower in the distance. The promenade is used by visitors to New Brighton who would take the ferry to Seacombe and then enjoy the walk, exercise and fresh air. It is the ideal vantage point to view the ever-changing maritime scene on the River Mersey.

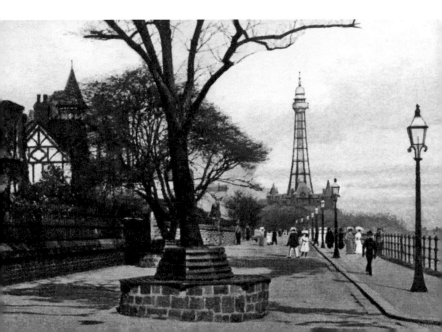

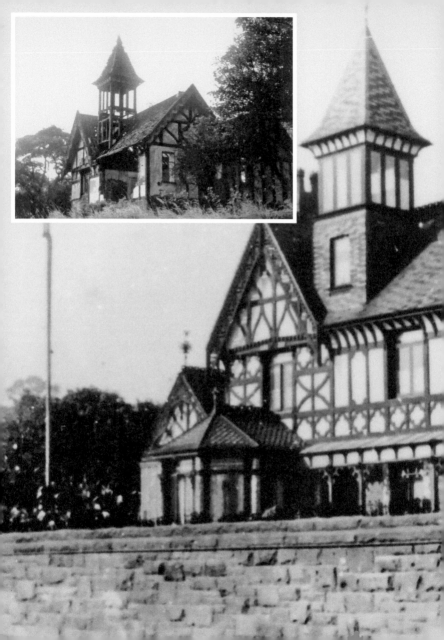

28. MOTHER REDCAP'S

Mother Redcap's was built in 1595 by the Mainwaring family, just above the water line of the Mersey between Egremont and New Brighton. The building was passed to the Davis family and was bought by Mrs Maddock in 1862. The front door was 5 inches thick, and there is evidence of a trapdoor inside that led to a cellar, so an intruder would fall 8 or 9 feet. The cellar was reputed to contain several secret compartments where smuggled goods were hidden from the police and customs and excise officers. It was purchased and restored by Mr J. Kitchingman in 1888 and he gave the land in front of the house to the council on the condition that it would not be used as a thoroughfare for vehicles. When the royal party used the promenade on a visit to the town he left the house, and it was used as a convalescent home for residents of Warrington. However, as it was unsuitable for this use, it was then opened as a café. It was demolished in 1974 and a nursing home was later built on the site.

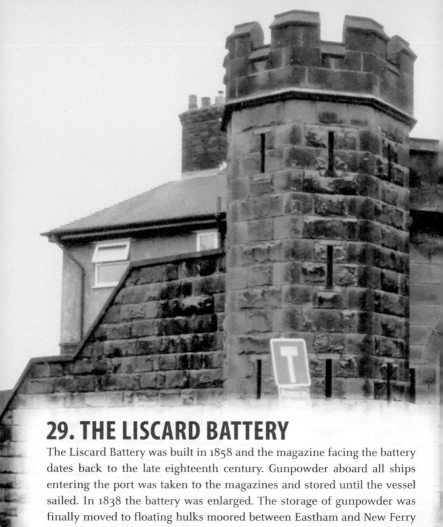

29. THE LISCARD BATTERY

The Liscard Battery was built in 1858 and the magazine facing the battery dates back to the late eighteenth century. Gunpowder aboard all ships entering the port was taken to the magazines and stored until the vessel sailed. In 1838 the battery was enlarged. The storage of gunpowder was finally moved to floating hulks moored between Eastham and New Ferry in the 1850s because of the increase in residential housing in the New Brighton area. The turreted gateway is still standing at the corner of Magazine Lane and the officers' toilets are still preserved in the grounds of a local residential property.

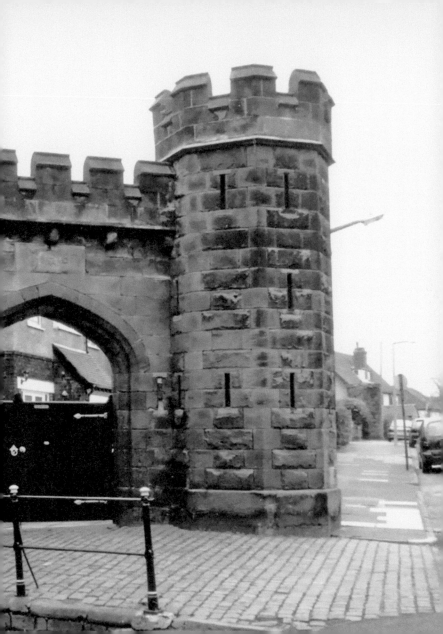

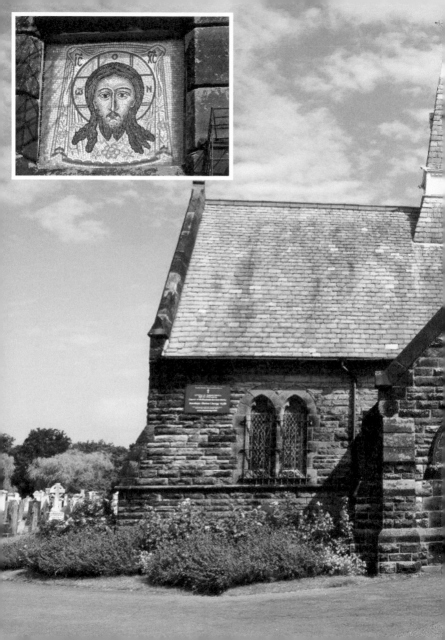

30. GREEK ORTHODOX CHURCH OF ST ELISABETH

The Greek Orthodox Church of St Elisabeth is in the parish of the Russian Orthodox Church Outside Russia (ROCOR) in the diocese of Great Britain and Ireland. The congregation includes people from the Russian Federation, the Baltic States, Romania, Serbia and the United States of America who have converted to Orthodoxy or are exploring the faith. The Julian calendar is used and the services are mainly in English with some Church Slavonic. The Divine Liturgy is served every Sunday at 10.00 a.m., and 2019 was the tenth anniversary of the parish moving to the church.

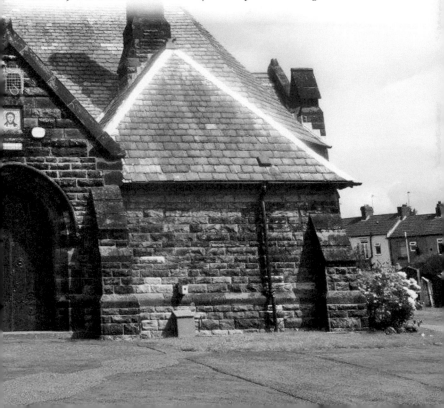

31. VALE PARK

Vale Park was formed by the amalgamation of the 'Liscard Vale' and 'Woodlands' estates in 1898 by the Local Board. The large house in the centre of the grounds was named Holland House. It was the home of the Holland family from 1844 to 1898 and the building now incorporates a café and college.

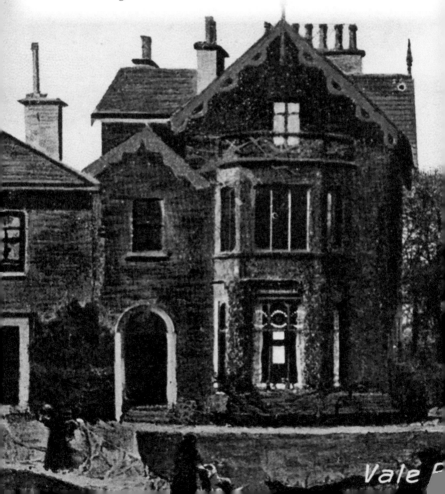

Vale P

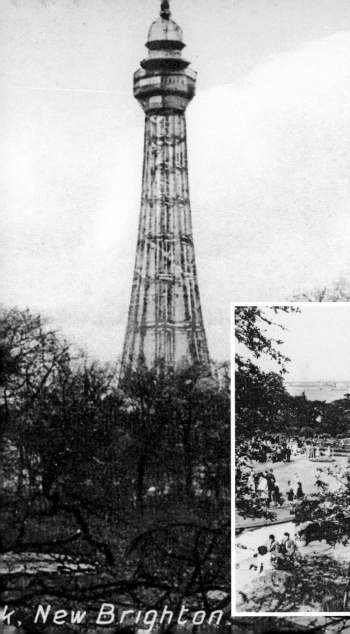

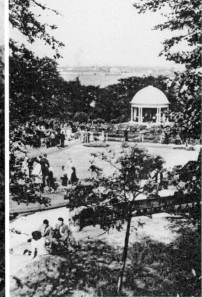

k, New Brighton.

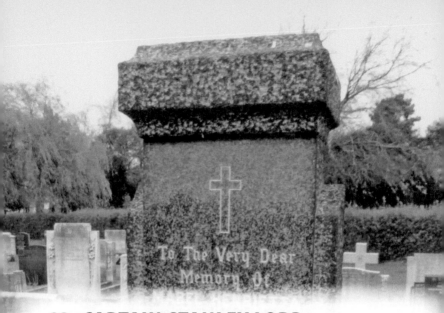
To The Very Dear
Memory Of

32. CAPTAIN STANLEY LORD

The grave of Captain Stanley Lord at the main cemetery in Wallasey. He is buried with his wife Mabel and son, Stanley. Captain Lord died on 24 January 1962, aged eighty-four years. He was born on 13 September 1877 at Bolton, Lancashire, and began his training when he was thirteen. Lord started his seagoing career with the Pacific Steam Navigation Company and was given his first command in 1906, becoming master of the *Californian* in 1911. On the evening of 14 April 1912 *Californian* approached a large ice field and decided to wait until the following day to proceed. During the night the officer on watch saw rockets being fired and Captain Lord was awakened but assumed they were company rockets. The following morning the lights from *Titanic* had disappeared and it was thought that she had left the area. The official inquiry found that the *Californian* was much closer to the *Titanic* than Captain Lord believed and that he should have awoken his wireless operator. Lord resigned from the Leyland Line in 1912 and joined the Nitrate Producers Steamship Company, where he remained until 1928, when he resigned on health grounds.

33. EARLSTON HOUSE

Earlston House was originally known as Liscard Manor House and was renamed Rose Mount around 1841 by its owner, George Grant, who was godfather to W. E. Gladstone. When it was acquired by Lowry Mann in 1857 it became Earlston House. It was purchased by the Local Board in 1898 and opened as the Central Library two years later. In 1911 the building was extended with a grant of £9,000 from Andrew Carnegie. The junior library is still situated in the original building.

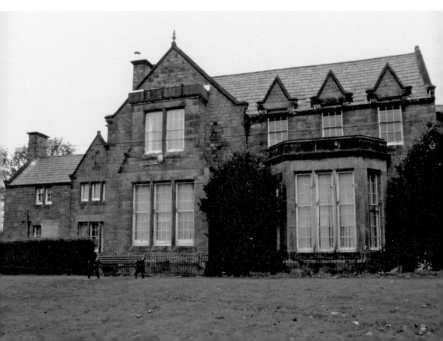

34. NEW BRIGHTON RAILWAY STATION

New Brighton railway station was opened on 30 March 1888 by the Seacombe, Hoylake & Deeside Railway, which merged with the Wirral Railway in 1891, forming Wirral Railways.

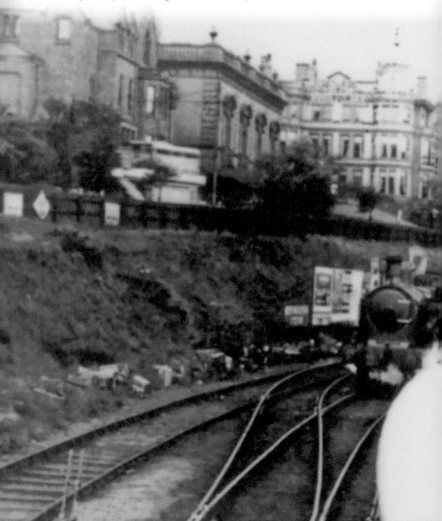

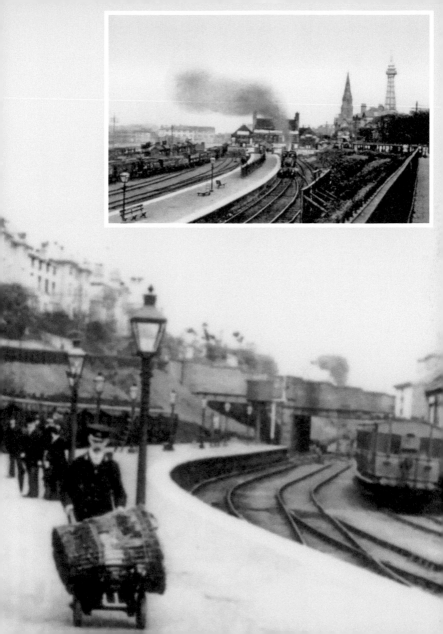

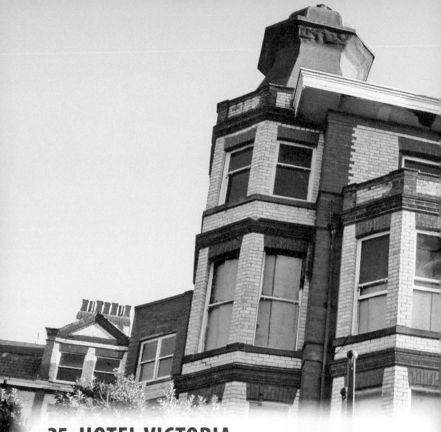

35. HOTEL VICTORIA

The Hotel Victoria at New Brighton was built of yellow and red brick in 1896. The hotel was designed with twenty-two rooms and had hot and cold water in each room. The Assembly Rooms were built in 1855 and were later combined with the Hotel Victoria – the two buildings were connected. The hotel was advertised as the 'Premier Residential Hotel in the Wirral Peninsula. Delightfully situated with private rooms for weddings, banquets etc., with a large ballroom and suite available and spacious car park.' The Hotel Victoria closed in 2007 and when it was demolished a block of luxury apartments was built on the site.

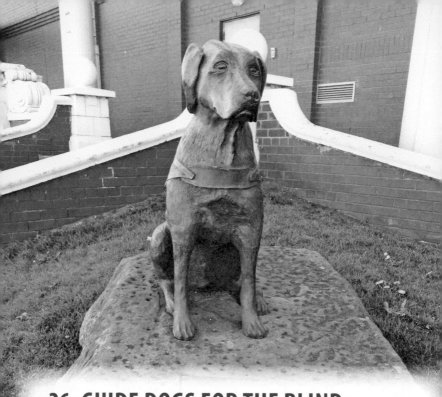

36. GUIDE DOGS FOR THE BLIND ASSOCIATION

The Guide Dogs for the Blind Association was founded at the Cliff, New Brighton, in 1931. This commemorative plaque and dog are situated outside the new Floral Pavilion Complex at New Brighton. Muriel Crooke and Rosamund Bond pioneered the training of the first four British guide dogs from a lock-up garage in Wallasey. William Debataz was appointed trainer and Captain Nicolai Liakhoff took over the role in 1933. The following year the Guide Dog Committee became the Guide Dogs for the Blind. Training took place at the Cliff in Wellington Road, where students would work with a dog for a month.

37. NEW BRIGHTON PIER

The end of the pier at New Brighton. Trams were operated from the bottom of Victoria Road from 17 March 1902 and ran to Seacombe. The trams turned in this area, which was nicknamed the 'Horseshoe'.

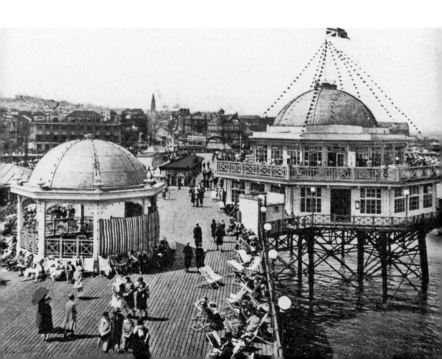

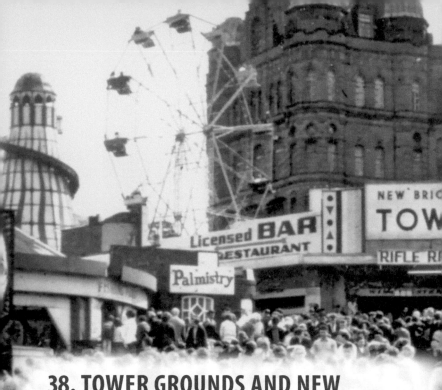

38. TOWER GROUNDS AND NEW BRIGHTON PIER

Work commenced on building the Tower on 22 June 1896, and it was completed in 1900 at a cost of £120,000. The Tower was 567 feet 6 inches high and 621 feet above sea level. The architects for the project were Maxwell & Turk of Manchester and it was built by Handysides & Company of Derby. The New Brighton Tower and Recreation Company was established with a share capital of £300,000, and an area of 20 acres at the Rock Point Estate was purchased. The idea was based on the Eiffel Tower in Paris and it included an assembly hall and winter gardens, On 5 April 1969 the building was destroyed by fire, leaving the shell, which was later demolished.

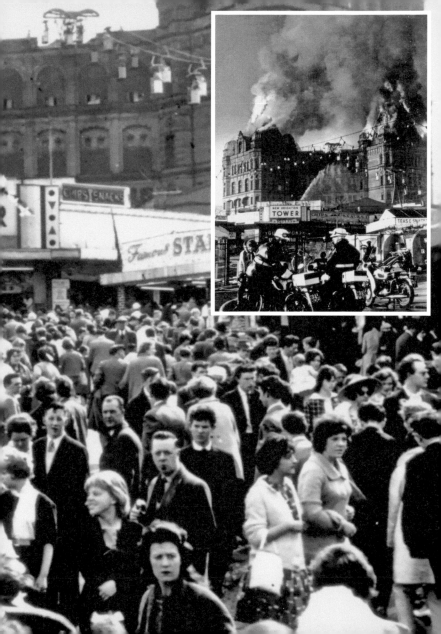

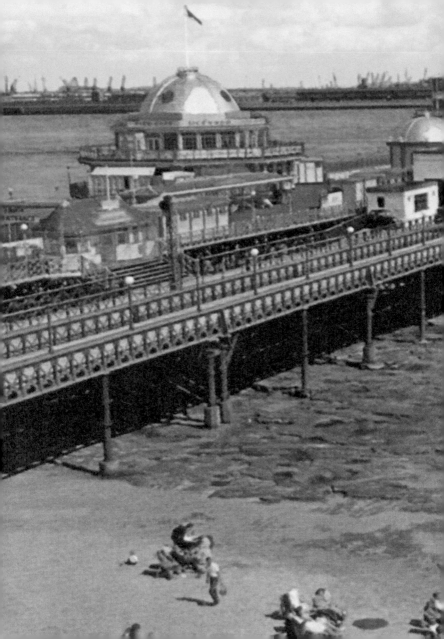

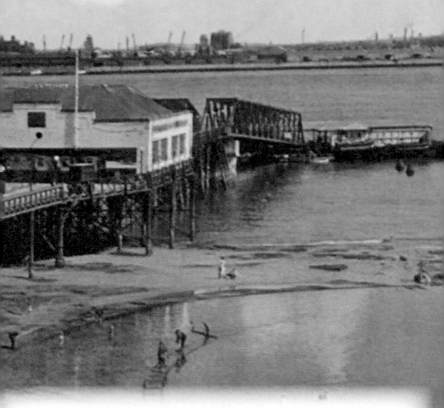

39. THE PROMENADE PIER

The Promenade Pier was opened on 7 September 1867 and extended in 1900 to the new promenade, which had been completed the previous year. A new pavilion was constructed on the pier at the promenade end in 1913. This was closed in 1923 until the pier was purchased by Wallasey Corporation in 1927. The structure was renovated in 1930, and was popular until the decline of the resort in the 1960s. The ferry pier was demolished in 1973 and the Promenade Pier in 1978.

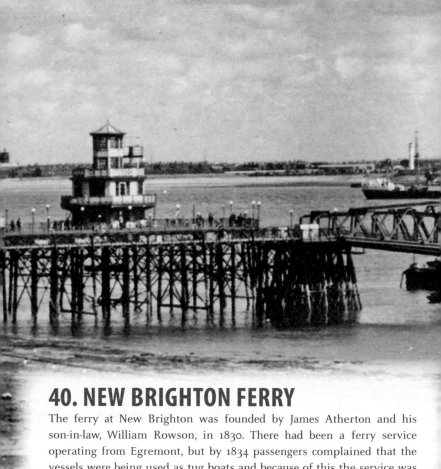

40. NEW BRIGHTON FERRY

The ferry at New Brighton was founded by James Atherton and his
son-in-law, William Rowson, in 1830. There had been a ferry service
operating from Egremont, but by 1834 passengers complained that the
vessels were being used as tug boats and because of this the service was
unreliable. In 1835 the Egremont Steam Ferry Company was formed
to run an improved service and introduce steam-powered vessels on
the route. The Egremont and New Brighton ferries were purchased by
Edward W. Coulbourn in 1850 and transferred to the Wallasey Local
Government Board in 1861.

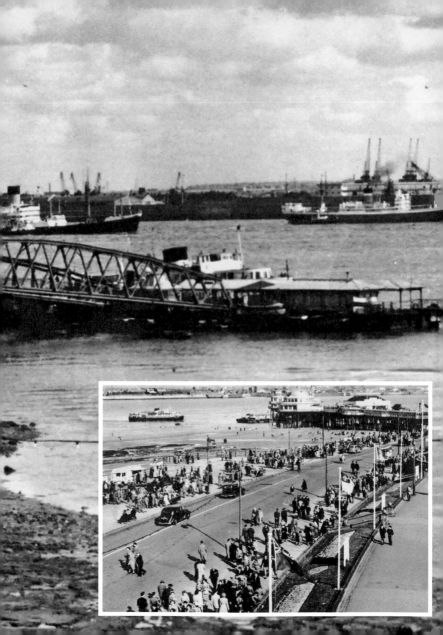

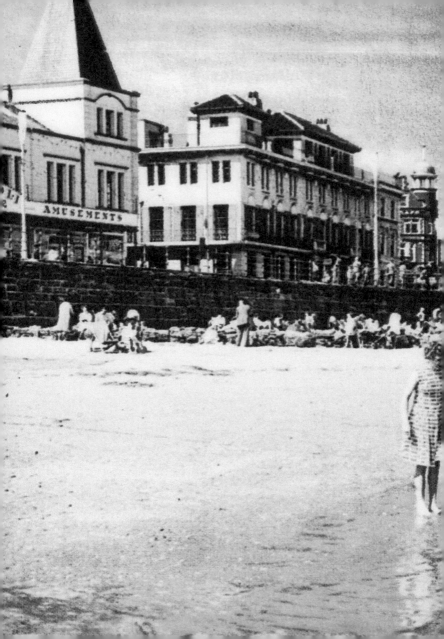

41. NEW BRIGHTON BEACH

Visitors enjoy the summer on the beach at New Brighton. A guidebook of 1904 stated that, 'The sands are, perhaps, unrivalled for their vast stretch, extending to the Estuary of the Dee, and are firm and safe. The view of the Mersey, with the constantly changing scene of the arrivals and departures of Atlantic liners, sailing vessels and coastwise steamers.' Children were able to enjoy the ponies and donkeys and the various seaside amusements. Bathing cost *6d* per person or *4d* if two or more occupied the same machine.

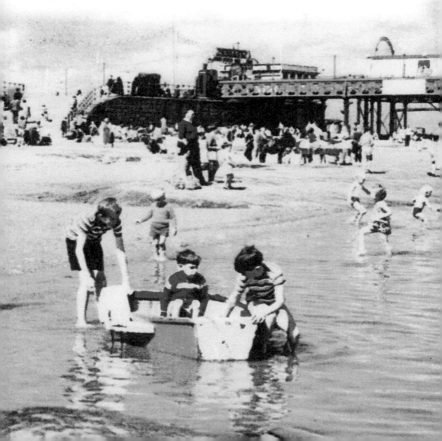

42. THE FLORAL PAVILION THEATRE

The Floral Pavilion Theatre, New Brighton, was built on the promenade when the 'Ham and Egg Parade' was demolished. It was opened in 1913 and operated by various organisations for several years. In 1925 it was redecorated and refurbished with seating for 1,200 people and was operated by Frank Terry and Os Battye. Tommy Handley and Rob Wilton appeared at the Floral Pavilion during the Second World War and the production *Melody Inn* was produced by Jackson Earle and Peggy Naylor from 1948 to 1970. The Floral was demolished in 2007 and a new theatre and conference hall was built on the site.

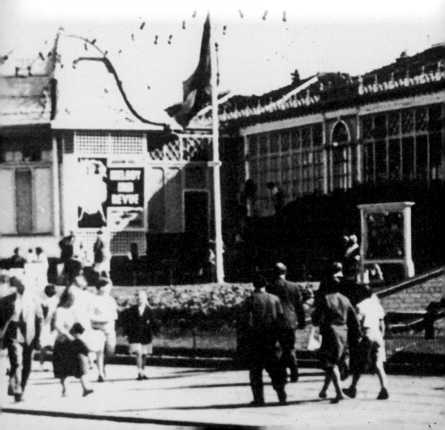

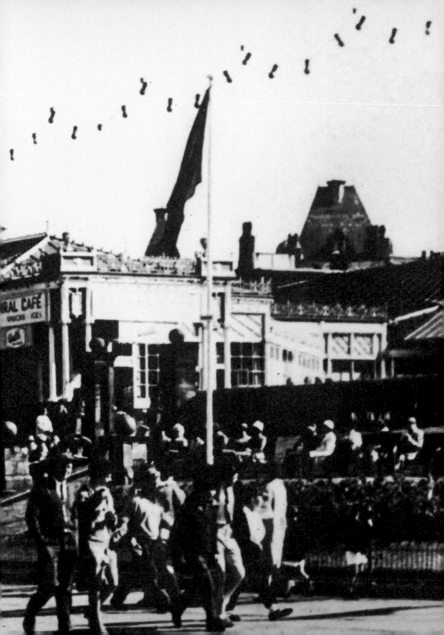

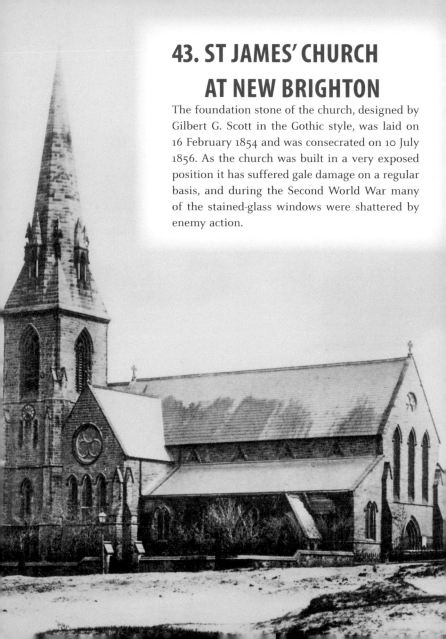

43. ST JAMES' CHURCH AT NEW BRIGHTON

The foundation stone of the church, designed by Gilbert G. Scott in the Gothic style, was laid on 16 February 1854 and was consecrated on 10 July 1856. As the church was built in a very exposed position it has suffered gale damage on a regular basis, and during the Second World War many of the stained-glass windows were shattered by enemy action.

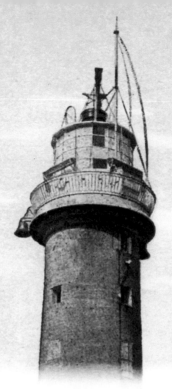

44. THE LIGHTHOUSE
AT NEW BRIGHTON

The foundation stone was laid by Thomas Littledale, Mayor of Liverpool, on 8 June 1827. The building work was very slow as the construction could only take place in the summer months; it was not completed until 1830. It was built of Anglesey granite, with the stones dovetailing into each other, and was coated with a volcanic material from Mount Etna, which became harder in time than the stone itself. The light is 77 feet above the rocks and had a range of 14 miles. However, following the installation of a new radar system for the port, the light shone for the last time on 1 October 1973.

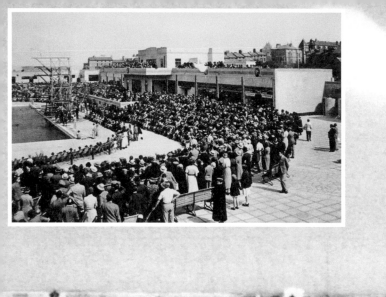

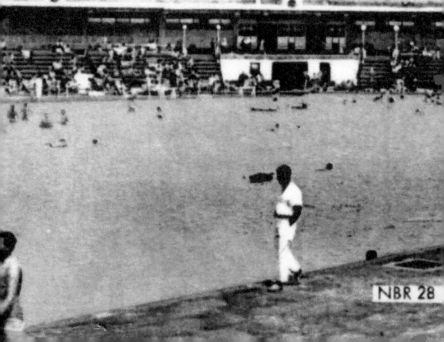

NBR 28

45. NEW BRIGHTON BATHS

New Brighton Baths were opened by Viscount Leverhulme on 13 June 1934 and were advertised as the largest outdoor swimming pool in Europe. The pool was designed to accommodate over 2,000 swimmers and 10,000 visitors. The bathing pool was damaged during the storm of 1990 and was demolished. There is now a large shopping development built on the site.

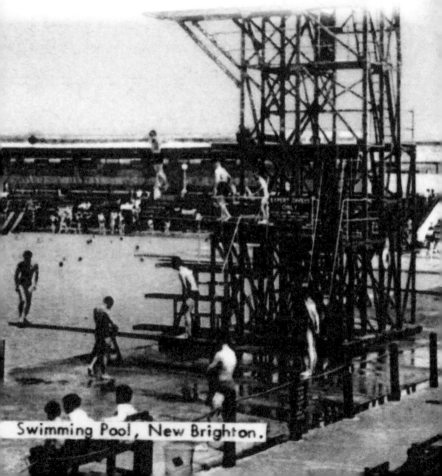

Swimming Pool, New Brighton.

46. FORT PERCH ROCK

Fort Perch Rock at New Brighton was designed to hold 100 men, but it was normally staffed by only a handful. In the 1850s the Rock Channel began to silt up, and traffic entered the Mersey via the Crosby channel. Also, the building of iron-clad armoured ships meant that there was a need for more powerful guns. The defences at the port were replaced in 1893 by a pair of Maxim machine guns and the Royal Engineers carried out remodelling of the seaward towers and sea wall. This enabled three Mark VI 6-inch guns to be fitted in 1899. These were replaced in 1910 with Mark VII 6-inch guns, which had a range of 20,200 yards. The guns were last fired in 1951 during the Festival of Britain and were then moved to Woolwich Arsenal.

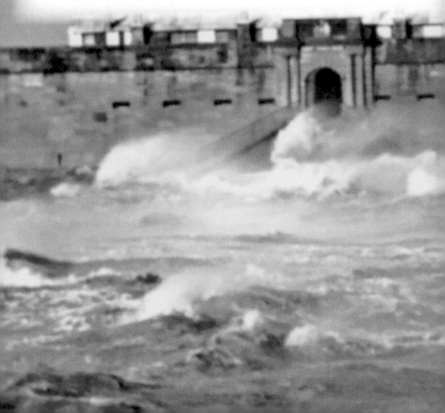

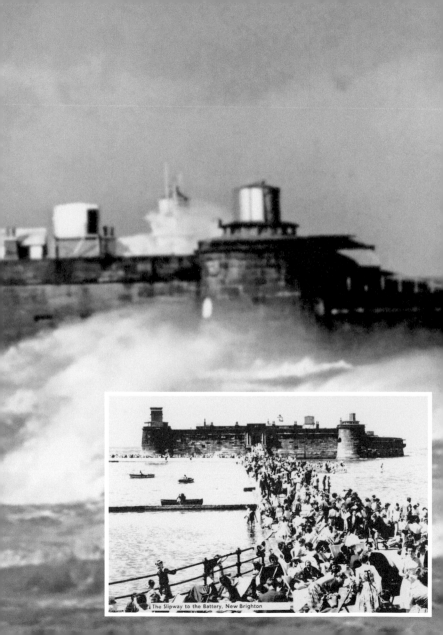

The Slipway to the Battery, New Brighton

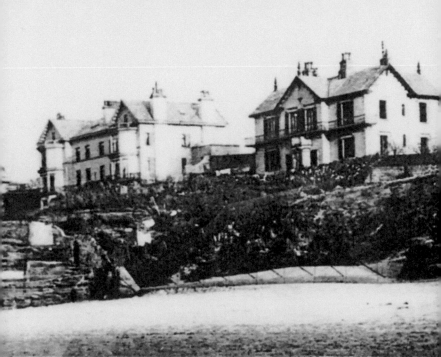

47. THE RED NOSES

The Red Noses at New Brighton are an outcrop of sandstone rock and were a favourite picnic spot in Victorian times. In 1931 Wallasey Corporation started work on a new sea wall and promenade on the coast in front of the Red Noses. The house on the right of the photograph is Rock Villa in Wellington Road. It was built by James Atherton over the famous Worm Hole Caves. Redcliffe is another large residence further along Wellington Road. It was built of Woolton red sandstone, which was brought down the river on barges from Runcorn and was then transported to the site by horse and cart.

48. THE DERBY POOL

The Derby Pool at Harrison Drive was opened by Lord Derby on 8 June 1932. It could accommodate 1,000 bathers and also 2,000 spectators. It was demolished in the 1970s and a public house named the Derby Pool has since been built on the site.

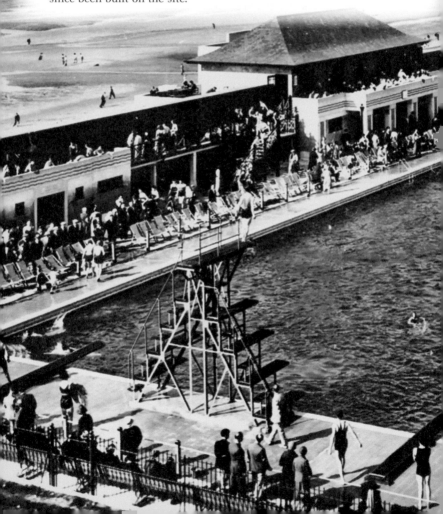

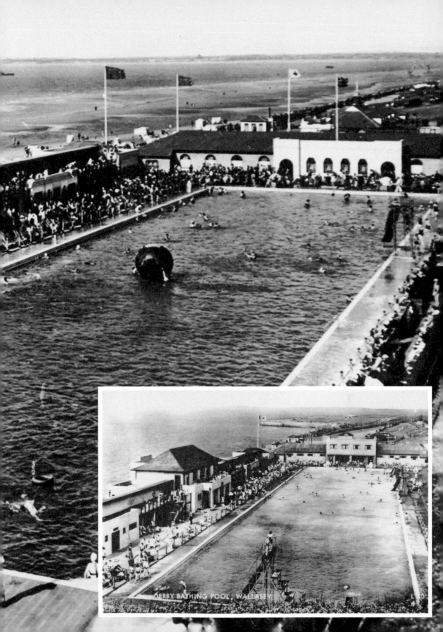

DERBY BATHING POOL, WALLASEY

49. ST NICHOLAS' CHURCH

St Nicholas' Church was built by the Harrison family, who were shipowners. It is known as the Harrison Memorial Church and is dedicated to James and Jane Harrison. The foundation stone was laid on 26 April 1910 and it was built of Storeton stone at a cost of £15,000. The Harrison Memorial Hall was built in 1932 nearby and consists of a stage that seats 500 people.

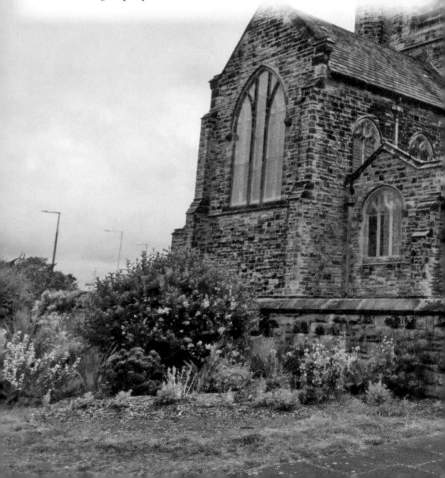

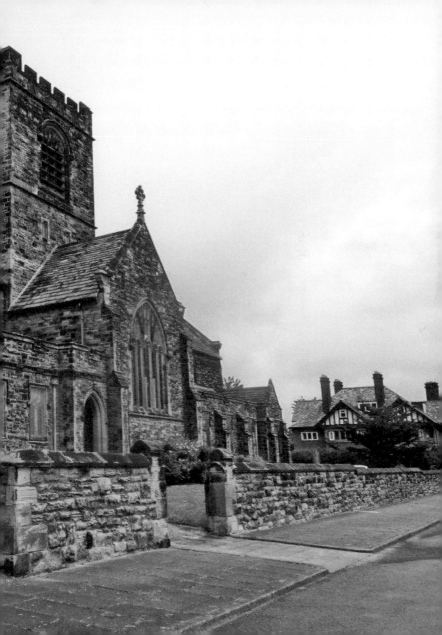

50. LEASOWE CASTLE

The original octagonal tower of Leasowe Castle was completed in 1593 by Ferdinando, 5th Earl of Derby. It was a vantage point for watching horse racing on a course between the castle and Wallasey Village. In the seventeenth century the castle was known as Mockbeggar Hall when it was deserted. It was purchased by Mrs Mary Boode in 1802 and was passed on to her son-in-law, master of ceremonies at the court of Queen Victoria, in 1826. He opened the building as a hotel but this venture proved unsuccessful and it became a residence in 1845. It was later purchased by the Trustees of the Railway Convalescent Homes, and during the Second World War it housed German prisoners of war.

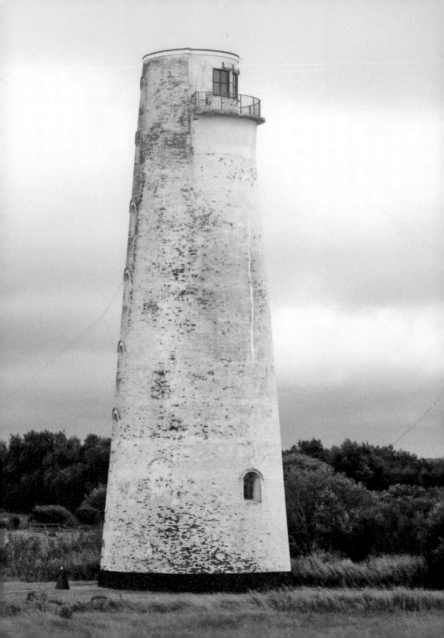

51. LEASOWE LIGHTHOUSE

Leasowe Lighthouse was known as the Upper Mockbeggar and is 100 feet high. It was built on bales of cotton and consists of seven floors with a cast-iron staircase. It was originally powered by an open coal fire until a catopric lantern with three burners was fitted in 1772. There were originally two lighthouses on the Upper Mockbeggar and Lower Mockbeggar and ships would line the two lights together when entering the channel. Mr and Mrs Williams were the last keepers and when Mr Williams became ill his wife continued looking after the lighthouse. Following his death she was appointed as keeper, with her daughter becoming her assistant. Mr and Mrs Williams had thirteen children. The lighthouse closed on 14 July 1908, and it was purchased by Wallasey Corporation for £900 in 1930.

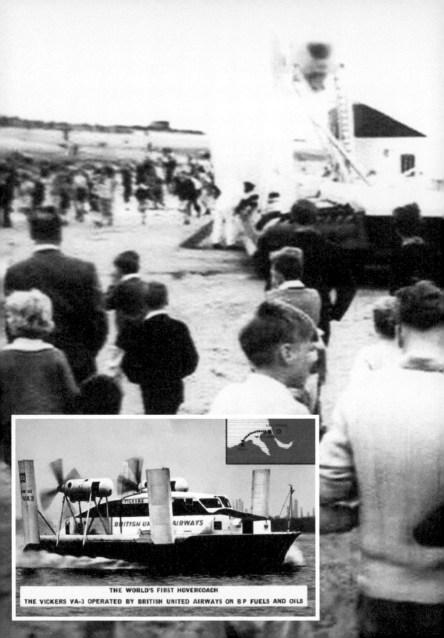

THE WORLD'S FIRST HOVERCOACH
THE VICKERS VA-3 OPERATED BY BRITISH UNITED AIRWAYS ON B P FUELS AND OILS

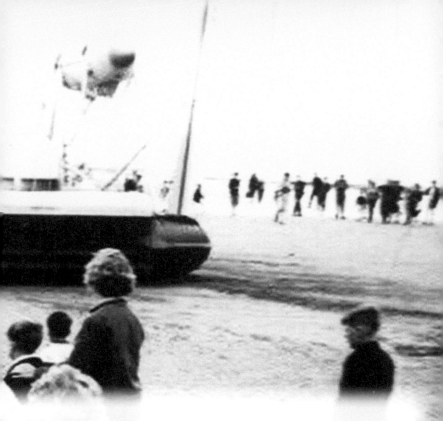

52. VICKERS VA-3 HOVERCRAFT

Vickers VA-3 Hovercraft was operated by British United Airways between Wallasey and Rhyl, North Wales, in 1962. The hovercraft commenced service on 20 July with the intention of providing twelve trips a day. It was advertised as operating for fifty-four days, but only ran nineteen of these because of adverse weather conditions and the failure of the rear lift engine. On 14 September its engine failed on a trip from Wallasey to Rhyl. Following several days of bad weather in the Irish Sea the craft was damaged and was eventually lifted out of the water by two mobile cranes on 17 September, when the service was terminated.

53. MORETON CROSS

The name Moreton was first recorded in 1278, from the Anglo-Saxon name meaning a 'settlement' ('tun') beside a 'marsh' ('more'). It is located between Meols to the west and Bidston and Wallasey Village to the south and east. Prior to the construction of a sea embankment the area included a tidal lagoon between 1 and 2 metres below sea level.